© 2016 Tammy Lawrence-Cymbalisty

All rights reserved. No part of this book can be reproduced in any form or mechanically stored in any retrieval system without written permission from the author.

ISBN-13: 978-1537680644

ISBN-10: 1537680641

Colouring Books By Tammy Lawrence-Cymbalisty:

My Mantra Colouring Book: A Yogini's Journey

This Stage of Grief: Colouring, Memory and Workbook

The Totem Animal Series - correspond to the astrological signs in the Native American Astrology Tradition which include:

My Owl Totem (Sagittarius)	My Bear Totem (Virgo)
My Woodpecker Totem (Cancer)	My Raven Totem (Libra)
My Wolf Totem (Pisces)	My Salmon Totem (Leo)
My Goose Totem (Capricorn)	My Snake Totem (Scorpio)
My Otter Totem (Aquarius)	Falcon Totem (Aries)
My Deer Totem (Gemini)	Beaver Totem (Taurus)

You have been invited to discover the feminine goddesses.

Their power will help you discover your true creativity, spirituality, health and wellness.

Ask for their help and guidance and they will aid you towards living a more fulfilling life experience. Invoke them, enjoy and be blessed with the creative power of the divine feminine.

At different points in your life you will find each goddess speaks to you in your time of need. There is nothing special you'll need to do other them ask them for their help. They are ready and willing to assist you in your journey. Be mindful to thank them for their guidance and help. Colour them, place them on your altar or bedside, speak to them... there is no right or wrong way to communicate with them; allow this book to help you begin. Most of all enjoy their power, everlasting love and support.

You'll find some modern day goddesses (Social media goddess, Asana Goddess, Gardening Goddess) and pages for you to journal & design the life you wish to live!

Go grab your markers, pens, pencil crayons or paints and your creative juices!

I would suggest placing a piece of paper (you could also choose waxed paper) behind the pictures particularly if you are choosing wet mediums to prevent any bleed-through. The pictures have a page between them to help with this additionally. However if you, like me, enjoy using acrylics or watercolour you may need the additional support for the page.

Happy colouring and creating!

Wishing you many continued blessings on your journey,

Tammy

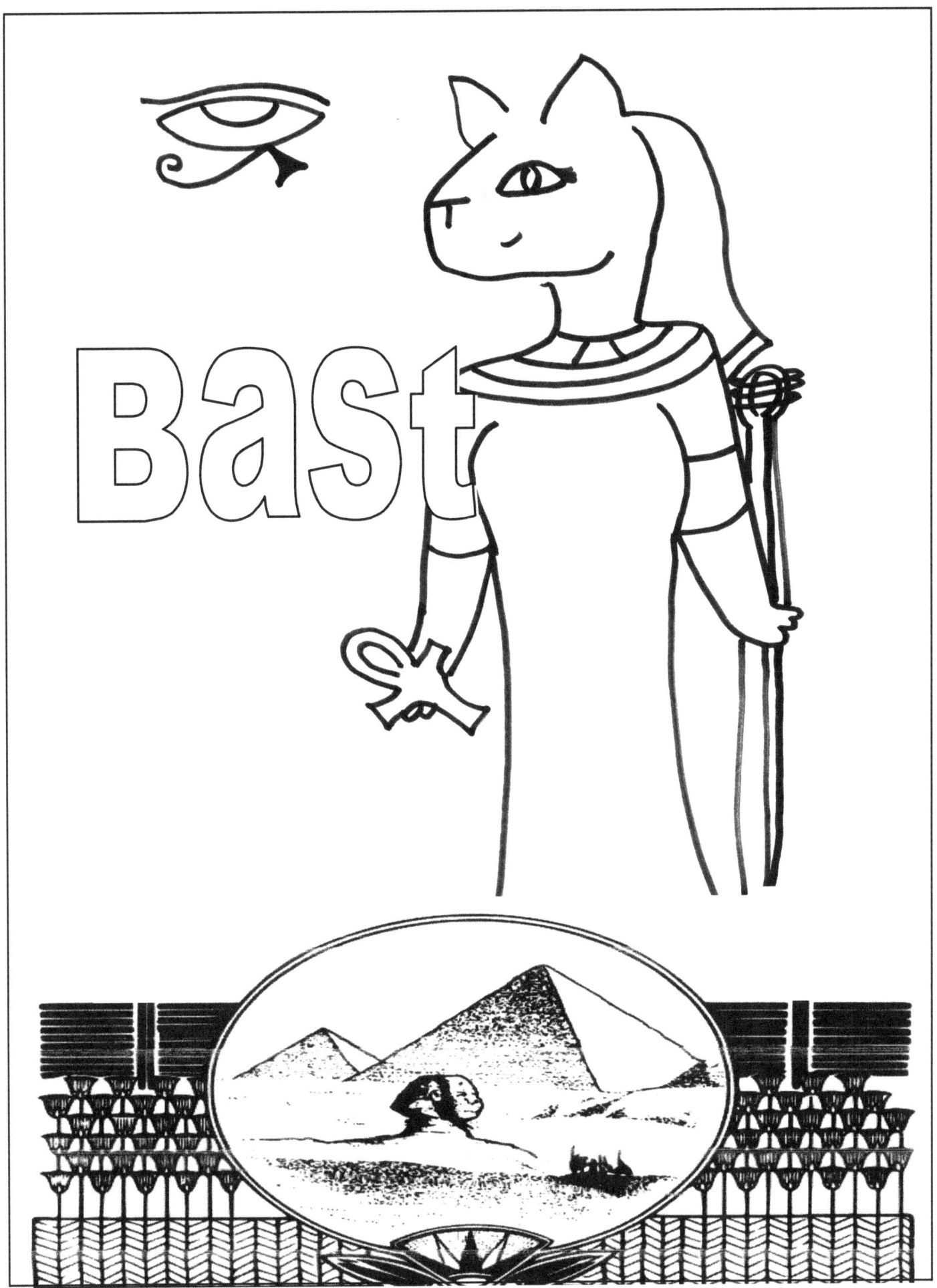

Bast

Goddess: Goddess of Protection, Goddess of Warfare

Tradition: Egyptian

Meaning: Protection, Healing, Fertility, Wellbeing, Personal boundaries

Gems: Cat's eye, Sunstone, Jasper, Lapis Lazuli, Pyrite

Colours: Black, Gold, Red, Turquoise, Silver

Sentence: Dance and sing my praise.

Mantra: "Grant us joy, song and dance and protect our journey."

Invoke: "Bast, Daughter of Ra, Divine Cat. fill us with peace, invoke your healing power and strengthen our desire."

Notes:

ISIS

Goddess: Queen of the Throne

Tradition: Egyptian, Greek

Meaning: Giver of life, Goddess of magic, Fertility goddess

Gems: Rose, Carnelian

Colours: Emerald, Turquoise

Sentence: I am my own healer.

Mantra: Chant her name in long sounds, "Iiiiissss-iiiissss"

Invoke: "Oh mighty Isis spread your powerful wings around me, help me to fly, to be free and find my power."

Notes:

Triple Goddess

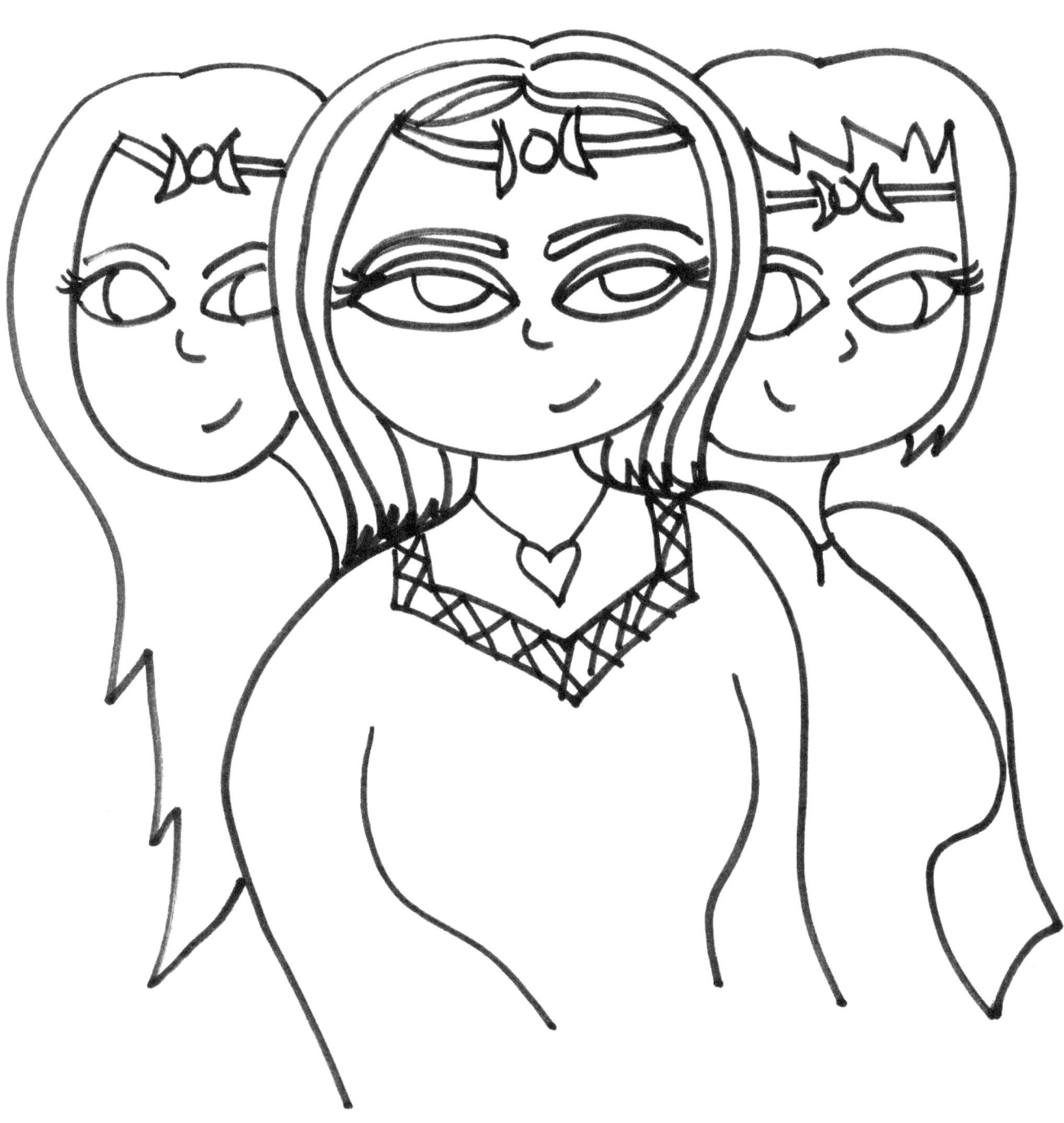

Triple Goddess

Goddess: Maiden, Mother, Crone

Tradition: Wiccan/Pagan Goddess

Meaning: Maiden guides new beginnings, Mother guides maturity and parenting, Crone guides us toward endings. Birth to rebirth.

Gems: Rainbow Moonstone

Colours: White, Red, Black

Sentence: Guide me through life.

Mantra: "Weave your light fair maiden, weave your glow loving Mother, weave your wisdom Crone."

Invoke: "Lovely maiden, Radiant Mother, Ancient queen hear my call."

Notes:

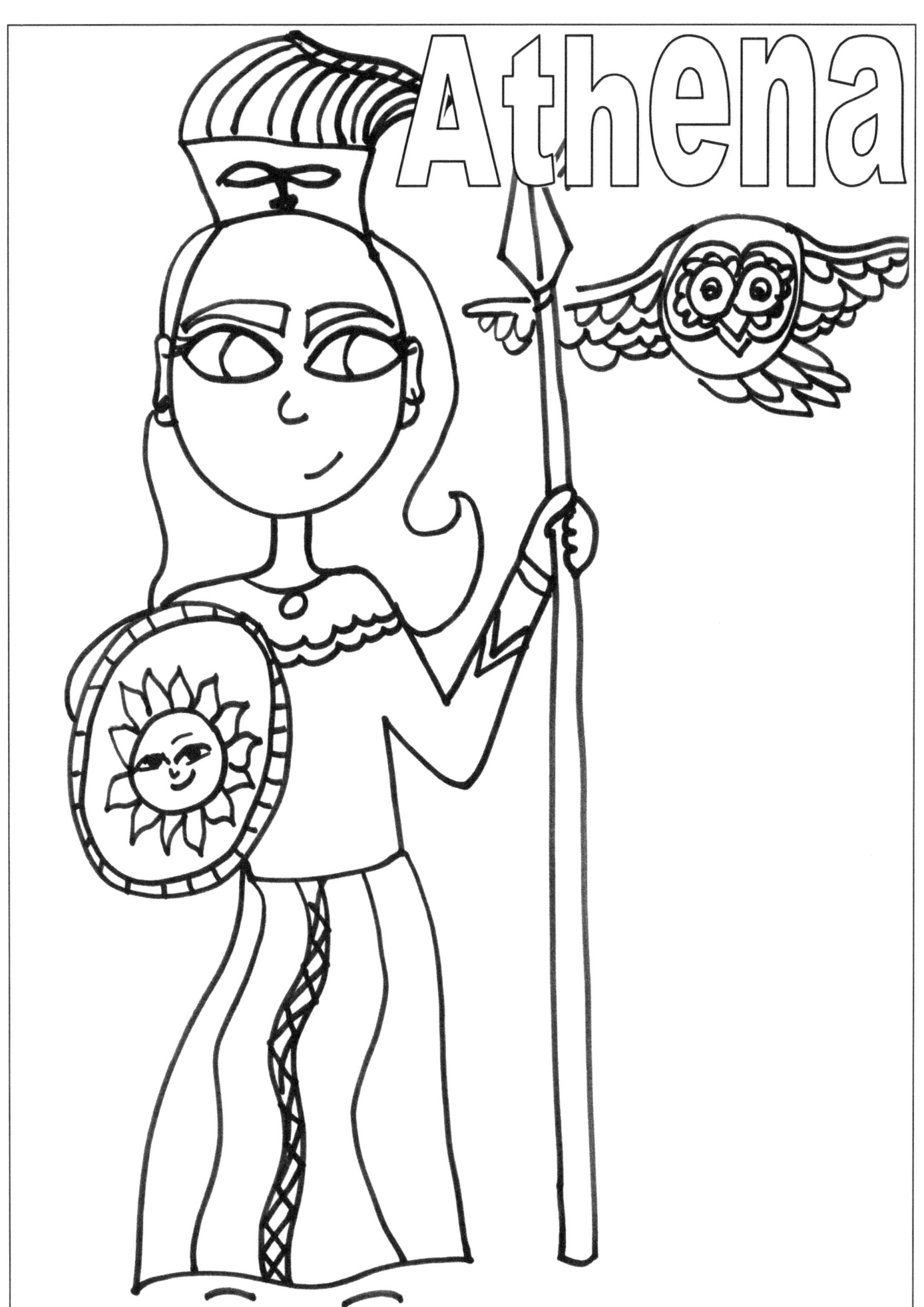

Athena

Goddess: Goddess of Wisdom

Tradition: Greek Goddess

Meaning: Goddess of art, intelligence, literature, reason

Gems: Onyx, ruby, ivory

Colour: Purple, blue

Sentence: Go in knowing

Mantra: "Fairness, wisdom and loyalty."

Invoke: "Powerful Athena, may you bring to the garden of my life the attributes of your wisdom."

Notes:

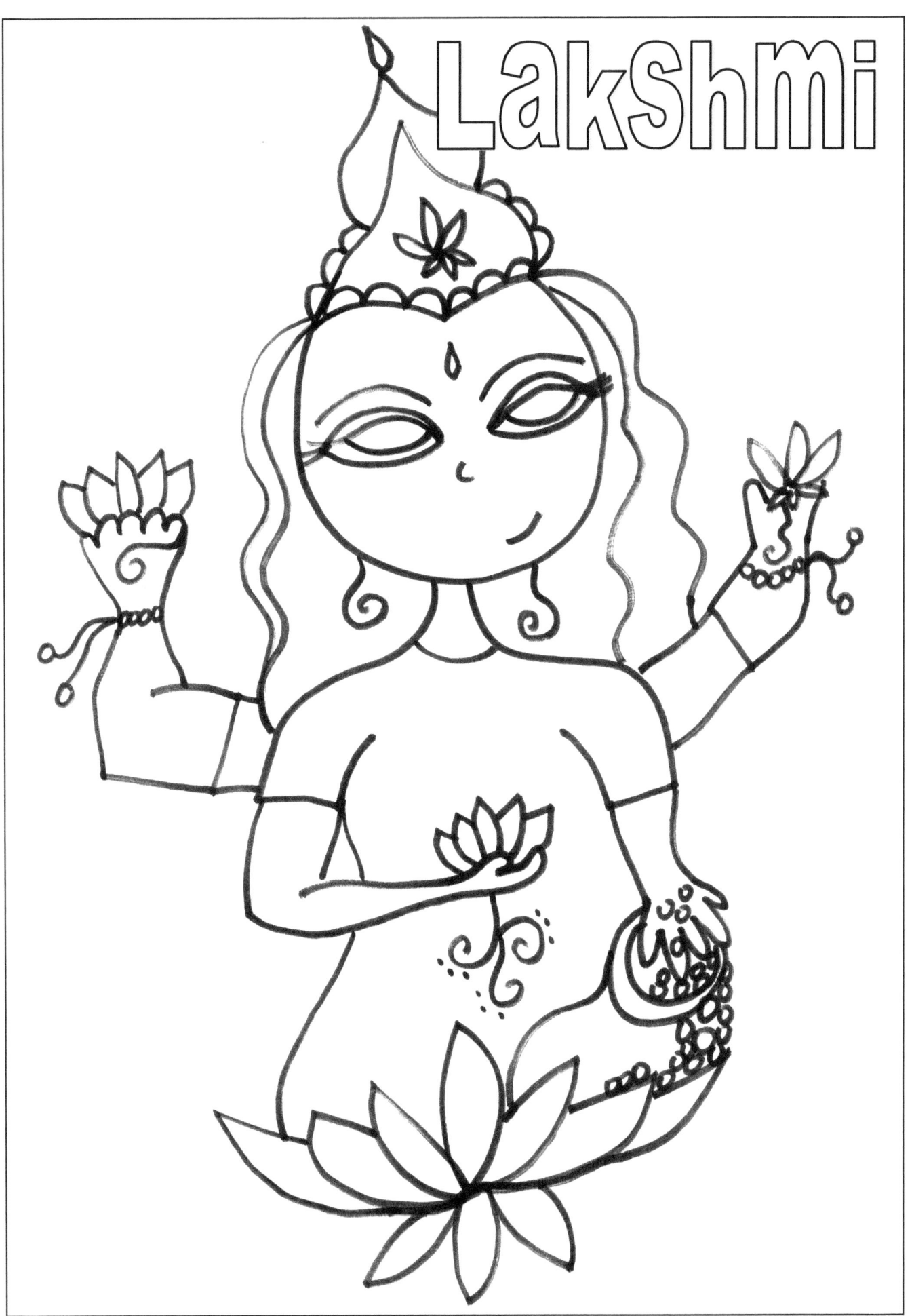

Lakshmi

Goddess: Lakshmi

Tradition: Hindu

Meaning: Goddess of Abundance for health, beauty and prosperity

Gems: Pearls, Peridot

Colour: Red and Gold

Sentence: Go in Faith

Mantra: "Om Shreem Lakshmi Swaha"

Invoke: "I invoke the great Divine feminine power of abundance into my life. Lakshmi guide me in my path."

Notes:

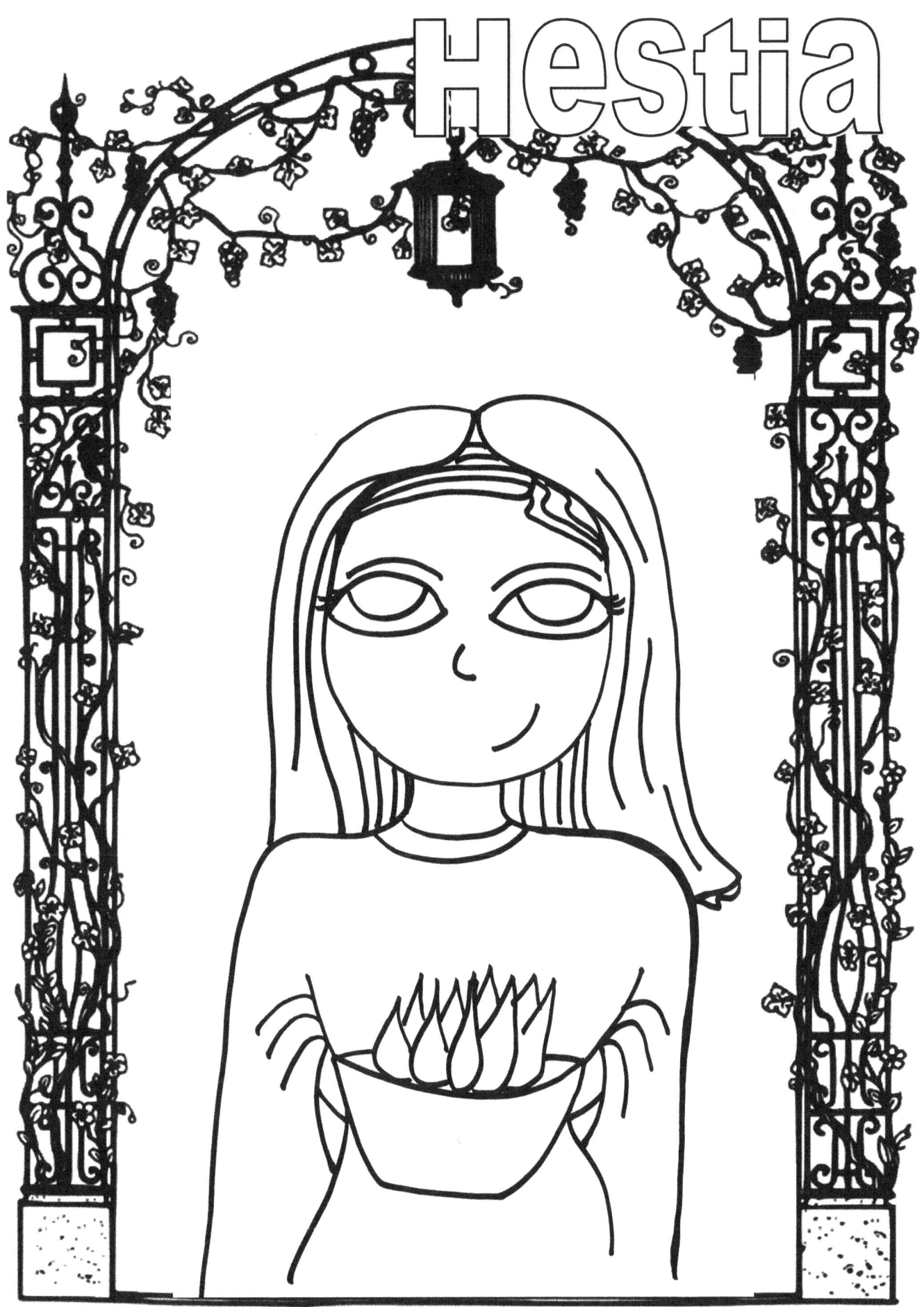

Hestia

Goddess: Goddess of Hearth & Home

Tradition: Greek

Meaning: For hearth, family, domestic life & relationships

Gems: Amethyst, Gold

Colour: Rose, Lavender, Silver

Sentence: Go where the heart is

Mantra: "Hestia bring me security, peace and comfort"

Invoke: "I invoke thee Hestia, rebalance my center and guide us towards peace."

Notes:

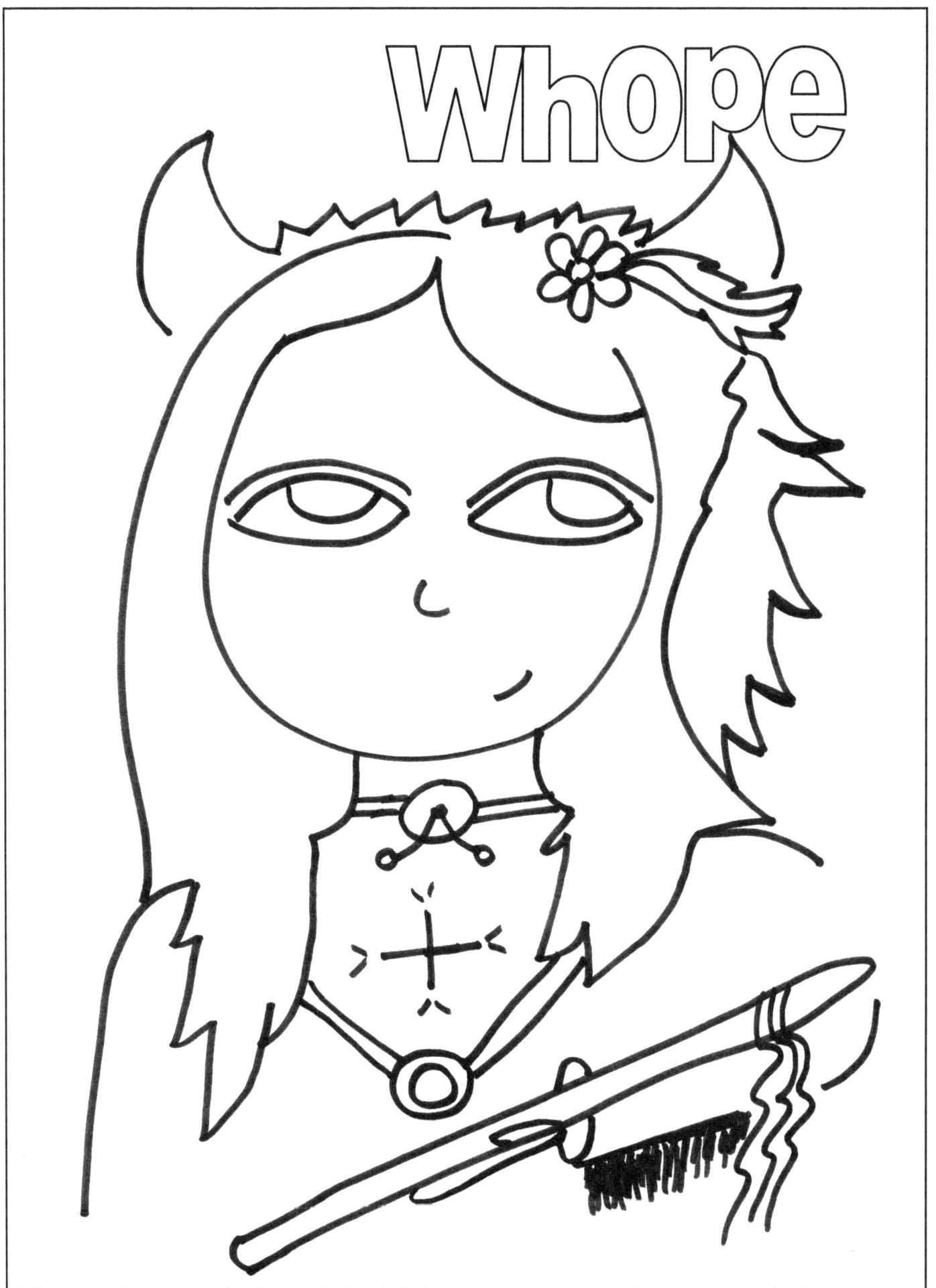

Whope

Goddess: Goddess of Peace, White buffalo

Tradition: Sioux Goddess, Lakota Goddess

Meaning: Name means "Meteor" or "falling star" Wish upon Whope when you see a falling star.

Gems: Turquoise, Chalcedony

Colour: White

Sentence: Go in Peace

Mantra: "Bless my friendships with all people"

Invoke: "I invoke the spirit of the white buffalo goddess to help us come together as one."

Notes:

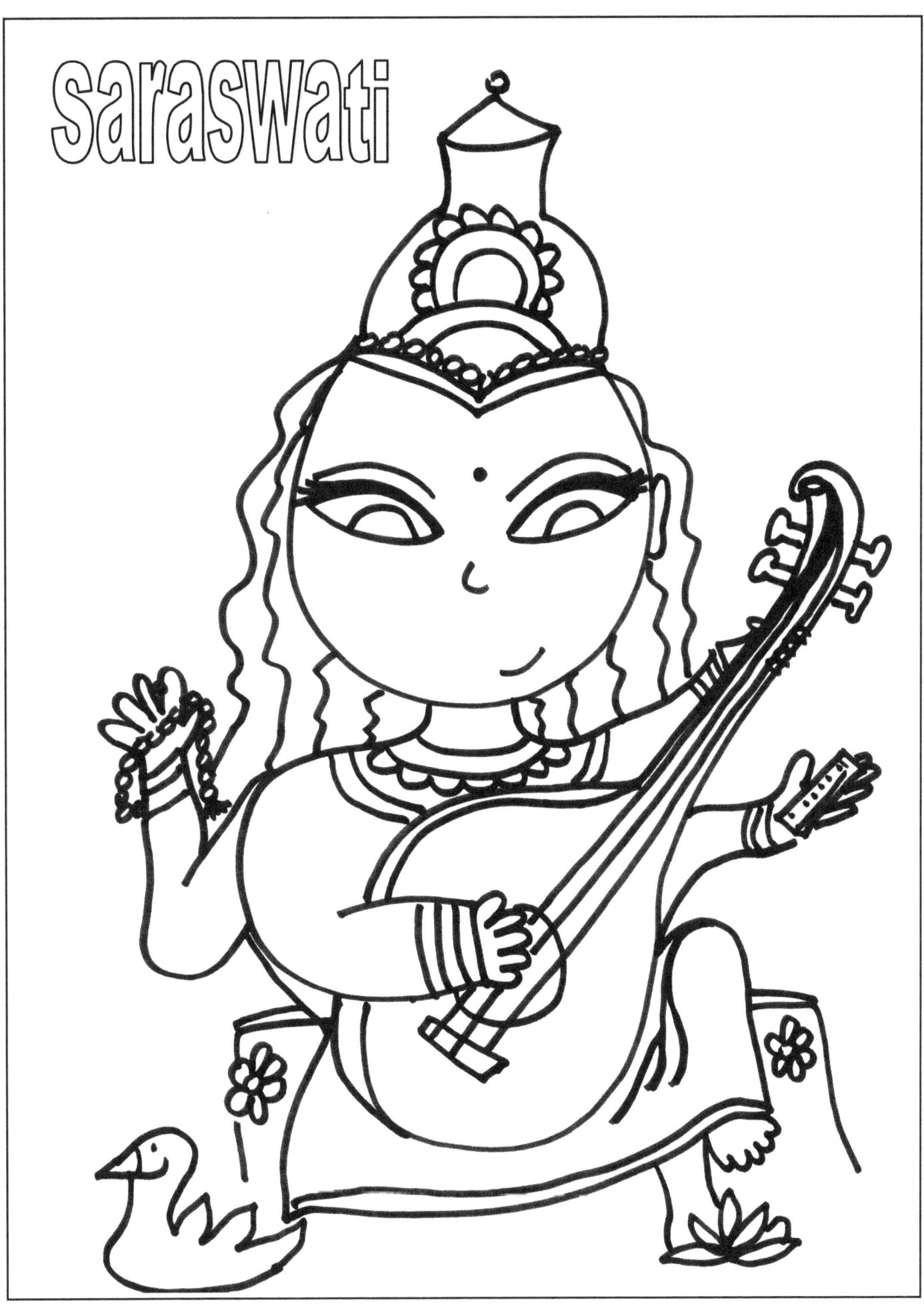

Saraswati

Goddess: Goddess of Knowledge

Tradition: Hindu

Meaning: Improves memory, concentration, learning, wisdom, music, arts & science

Gem: Pearl

Colours: Light blue, light violet

Sentence: Choose good over evil.

Mantra: "Om Aing Sarawathye Namah Om"

Invoke: "O Mother Saraswati bless my endeavors with wisdom."

Notes:

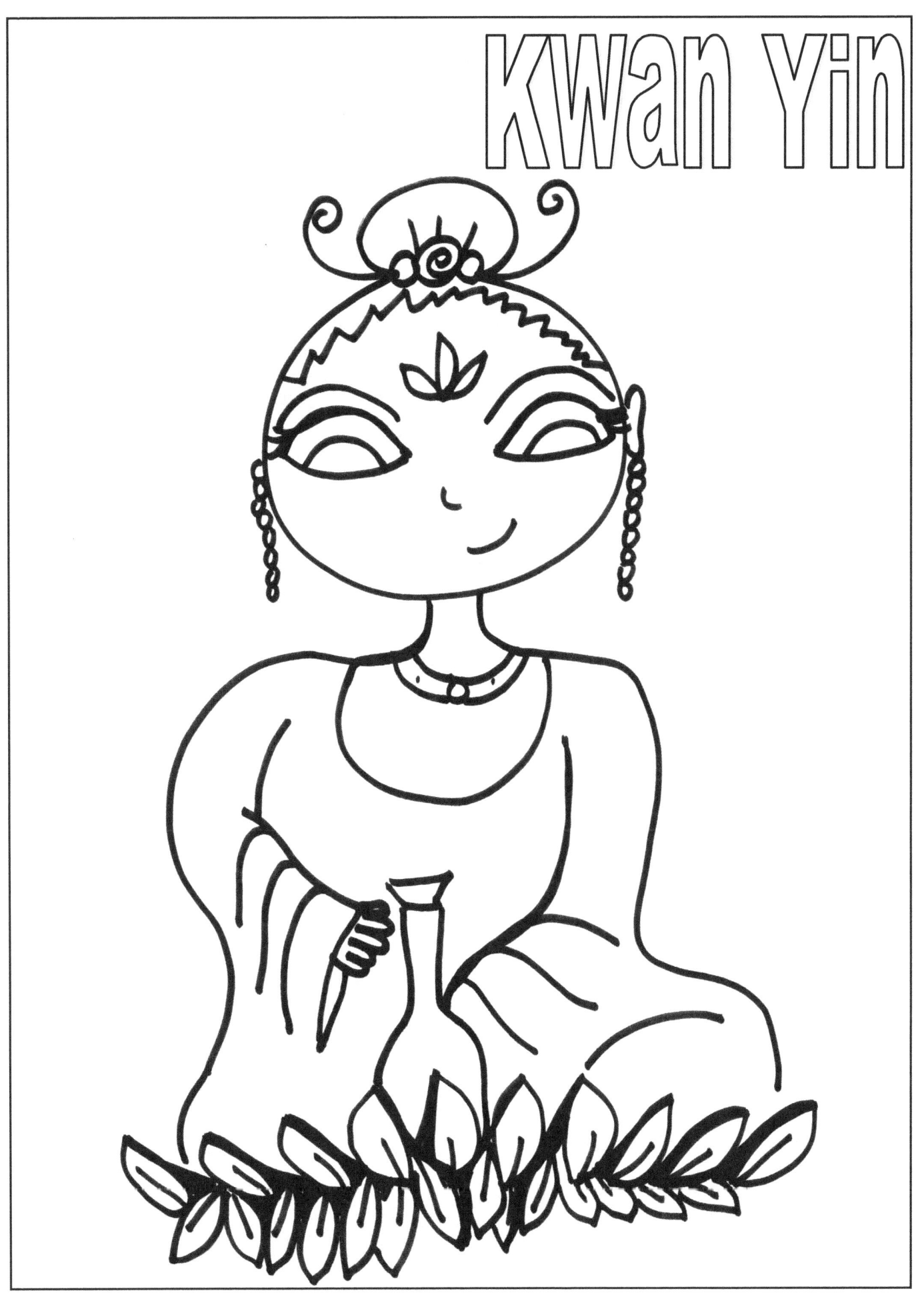

Kwan Yin

Goddess: Goddess of Compassion & Mercy

Tradition: Buddhist

Meaning: To save all beings from suffering, cure all ills (mental or physical), great healer

Gems: Rose quartz, Adventurine

Colour: White, pink, green

Sentence: Go in kindness

Mantra: "Om Mani Padme Hum"

Invoke: "Om, Hail to the jewel of the lotus."

Notes:

White Tara

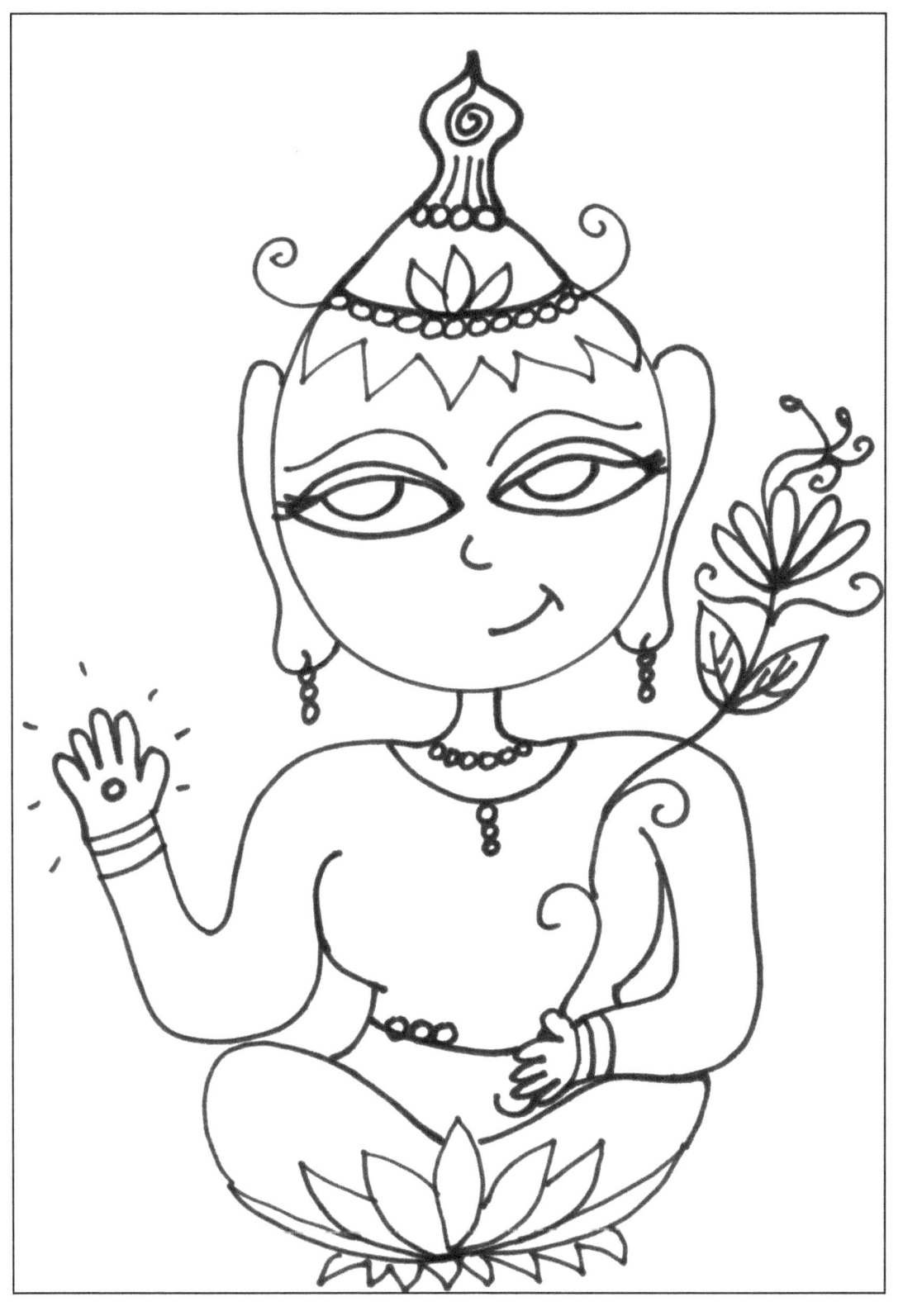

White Tara

Goddess: Goddess of Compassion

Tradition: Buddhist

Meaning: Peace, protection, longevity, prosperity

Gems: Diamond, Rose Quartz, Emerald

Colours: White, Green

Sentence: Go in protection.

Mantra: "Om Tare Tuttare Ture Svaha

Invoke: " Oh great Goddess of compassion, healing and protection Shine your light on me to create abundance, long life and happiness."

Notes:

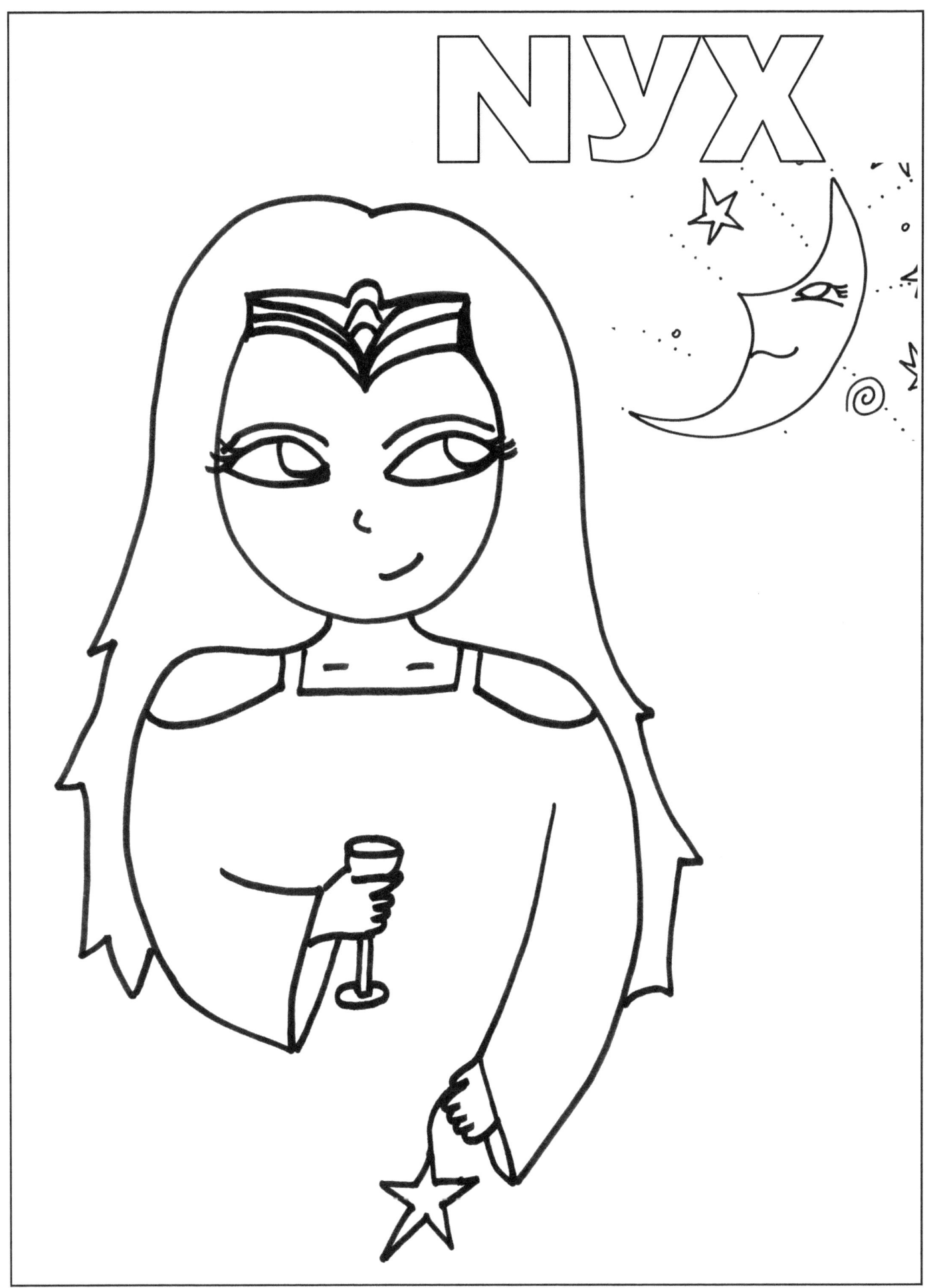

NYX

Goddess: Goddess of the Night

Tradition: Greek

Meaning: Helps to protect your dreams, relieves stress, Inspiration, muse

Gems: Moonstone, Agate

Colours: Black, Grey, Silver

Sentence: Go for your dreams.

Mantra: "May my sleep be peaceful"

Invoke: "Great Goddess Nyx I ask for your guidance and protection . Please bring blessings of your wisdom."

Notes:

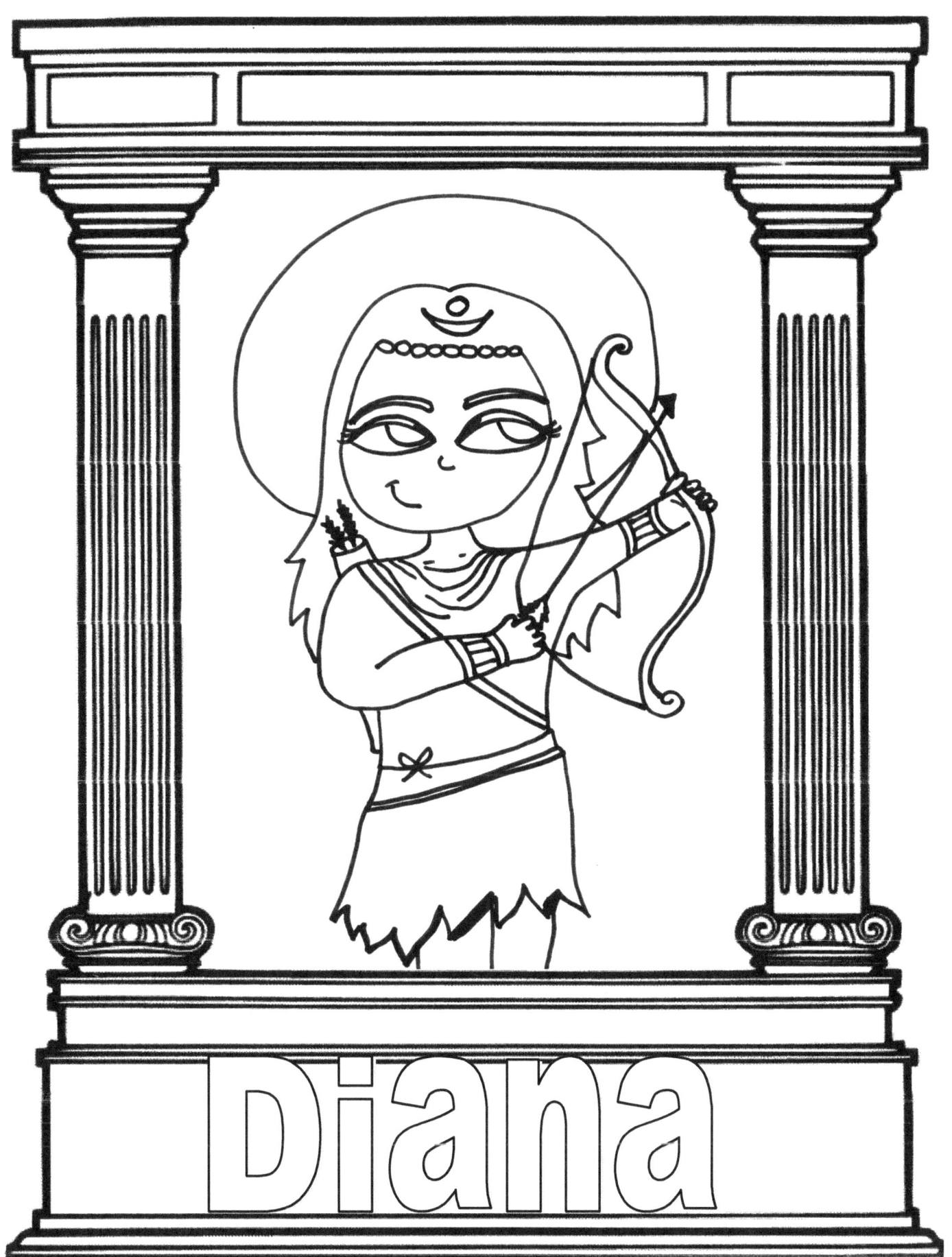

Diana

Goddess: Virgin Goddess of the Hunt & moon

Tradition: Roman

Meaning: Protector of childbirth & vulnerable people, fertility, abundance, harvest

Gems: Moonstone, Quartz, Diamond

Colour: Silver, white, red, green, turquoise

Sentence: Go in protection

Mantra: "Diana, Luna, Lucina"

Invoke: "I invoke the great Diana, goddess of light, guide and protect in my path."

Notes:

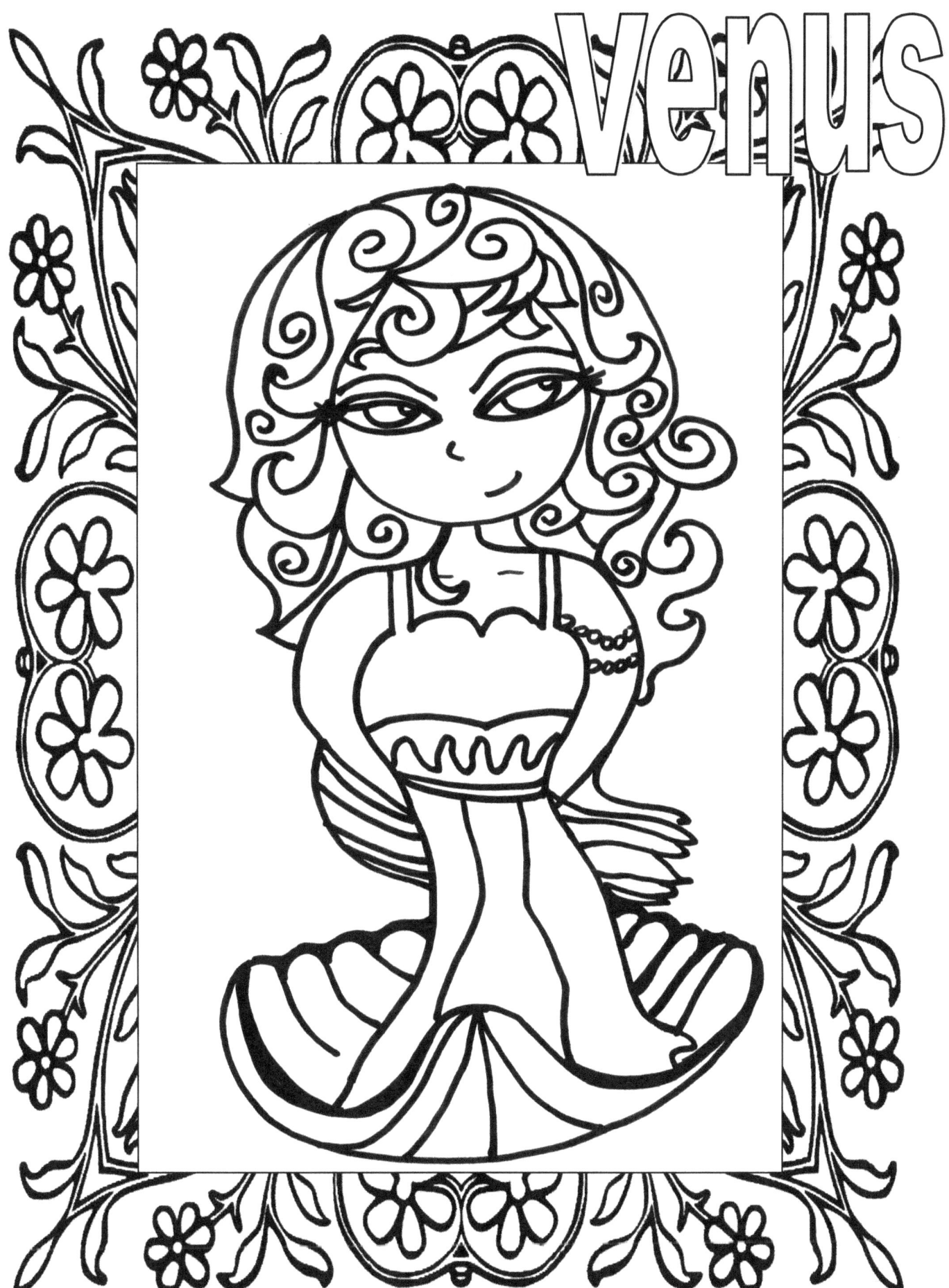

venus

Goddess: Goddess of Love

Tradition: Roman

Meaning: Love, sex, beauty, fertility

Gems: Rose Quartz

Colours: Pink, Red, Seafoam Green

Sentence: Go in love.

Mantra: "Om Klim Shum Shukraya Namah"

Invoke: "Oh Venus, beautiful one, share with me your powers of beauty, prosperity, victory and fulfillment."

Notes:

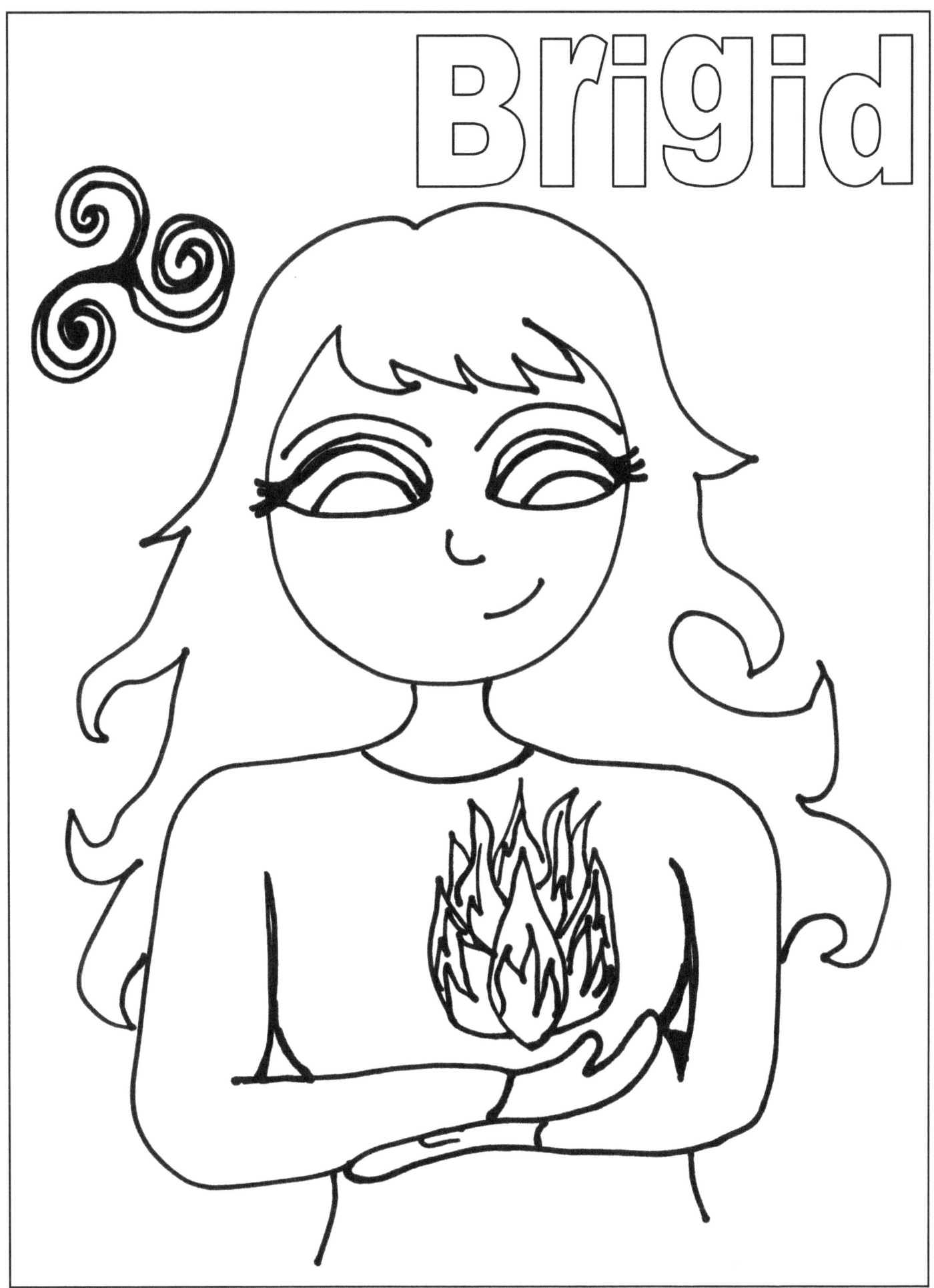

Brigid

Goddess: Goddess of Inspiration and Creativity

Tradition: Celtic Goddess

Meaning: Sun and moon, action, inspiration, healing, knowledge, skill, achievement

Gems: Agate, Amethyst, Jasper

Colours: White, Yellow, Red, Blue

Sentence: Bring renewal in your light.

Mantra: "Light the candles. Time for rebirth. The Sun returns to transform the earth"

Invoke: "Brigid, Goddess of the flame, shine your healing light to guide me. Let your flame inspire me and fill me with your knowing."

Notes:

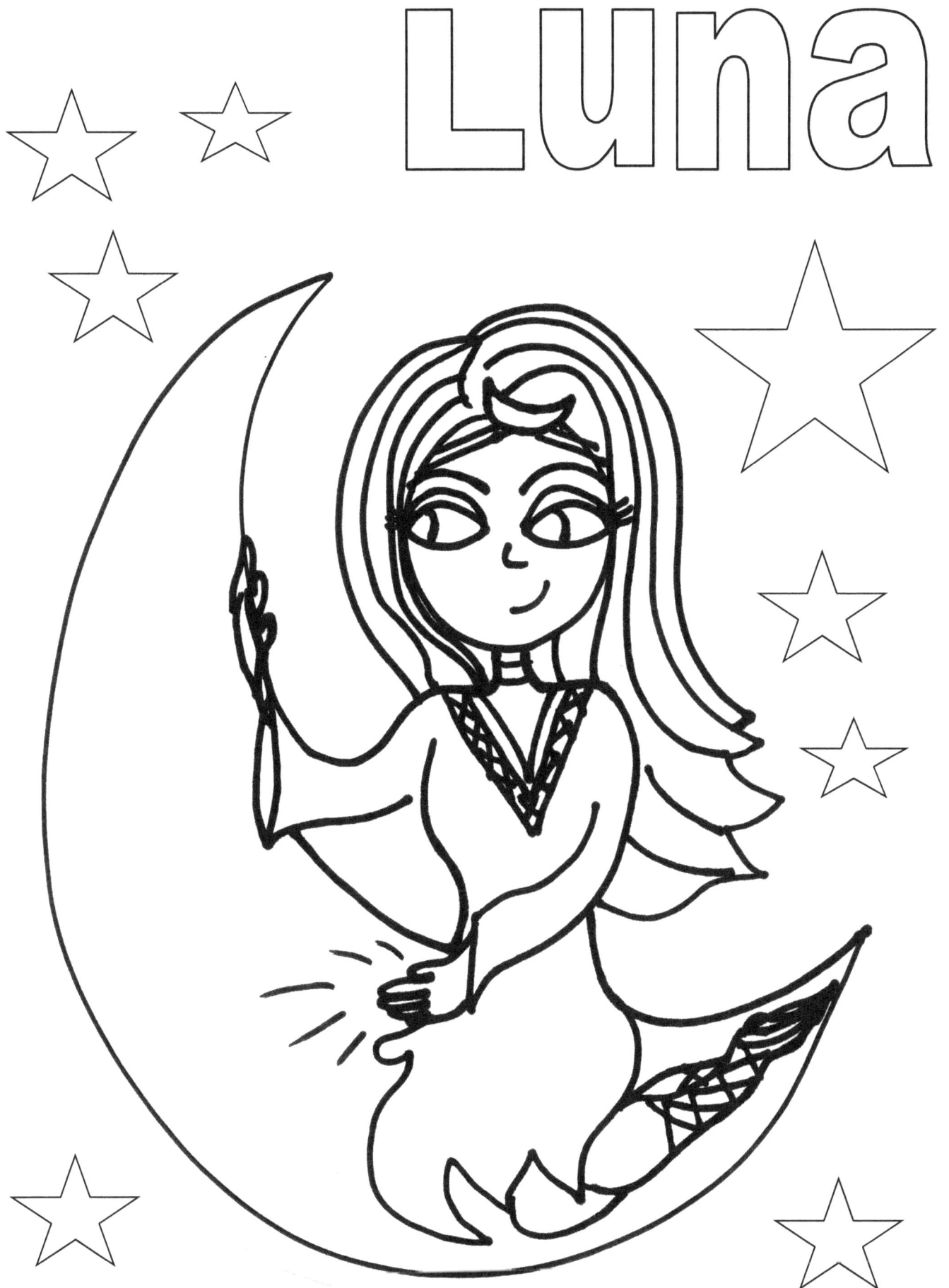

Luna

Goddess: Goddess of The Moon

Tradition: Roman

Meaning: To Shine

Gems: Moonstone, Pearl

Colours: Silver, Grey, White

Sentence: I am change. (In accordance to the phases of the moon: New Moon symbolises growth and new beginnings. Full Moon for manifestation. Waxing moon to banish or remove negativities.)

Mantra: "Om Shrim Som Somaya Namah"

Invoke: "Moon Lady, shine your light on me. Help to fulfill my true hearts desires"

Notes:

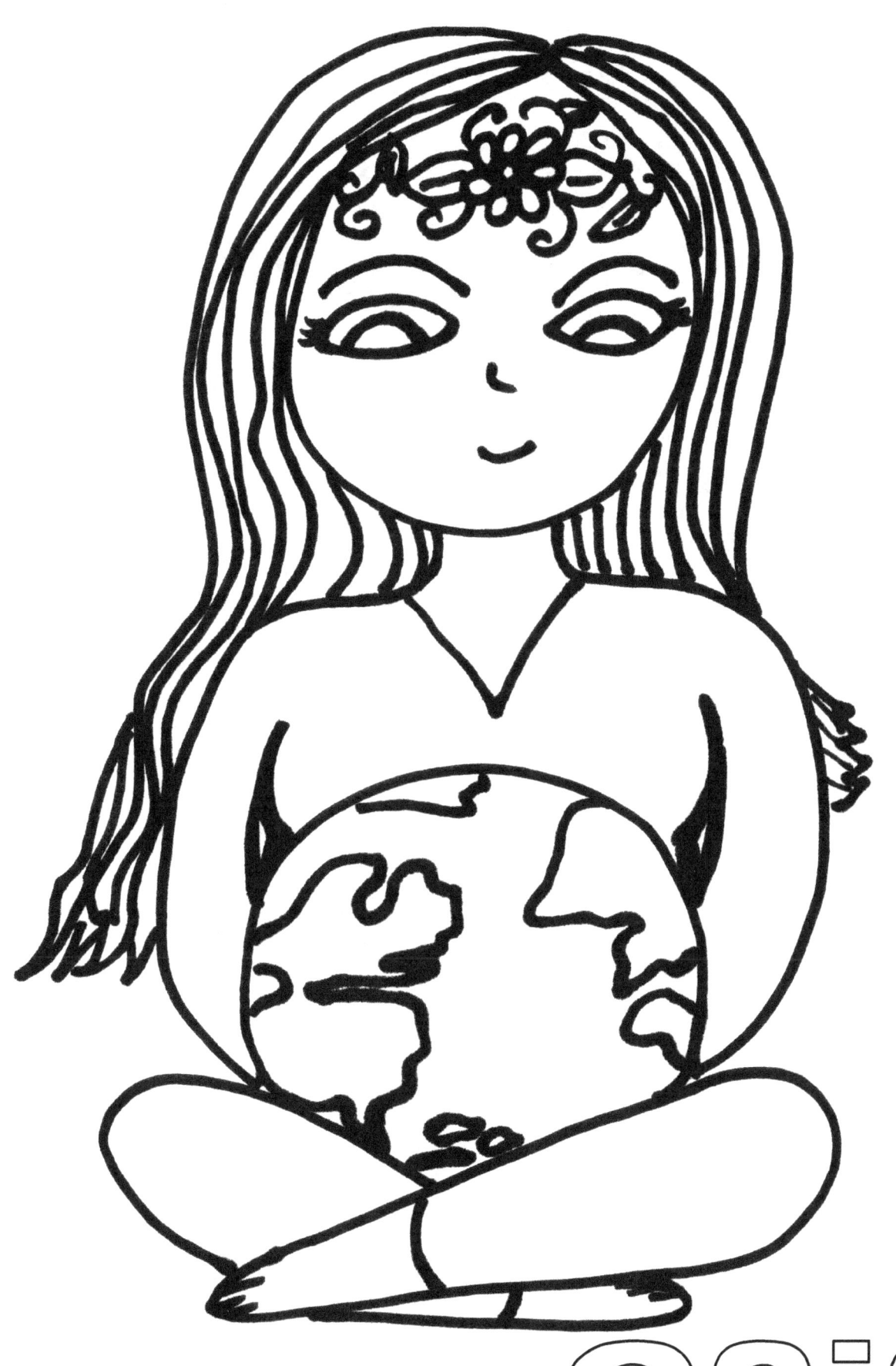

Gaia

Goddess: Goddess of The Earth

Tradition: Greek

Meaning: Giver of life, Mother to all, Concern for all life

Gems: Smoky Quartz, Black Tourmaline, Amber, Green Calcite

Colours: Green, Brown, Orange, Red

Sentence: Be in rhythm. Be in Peace.

Mantra: "Om Shanti, Shanti, Shanti"

Invoke: "Oh Great Gaia, mother of all, hear our prayer. Bless this child."

Notes:

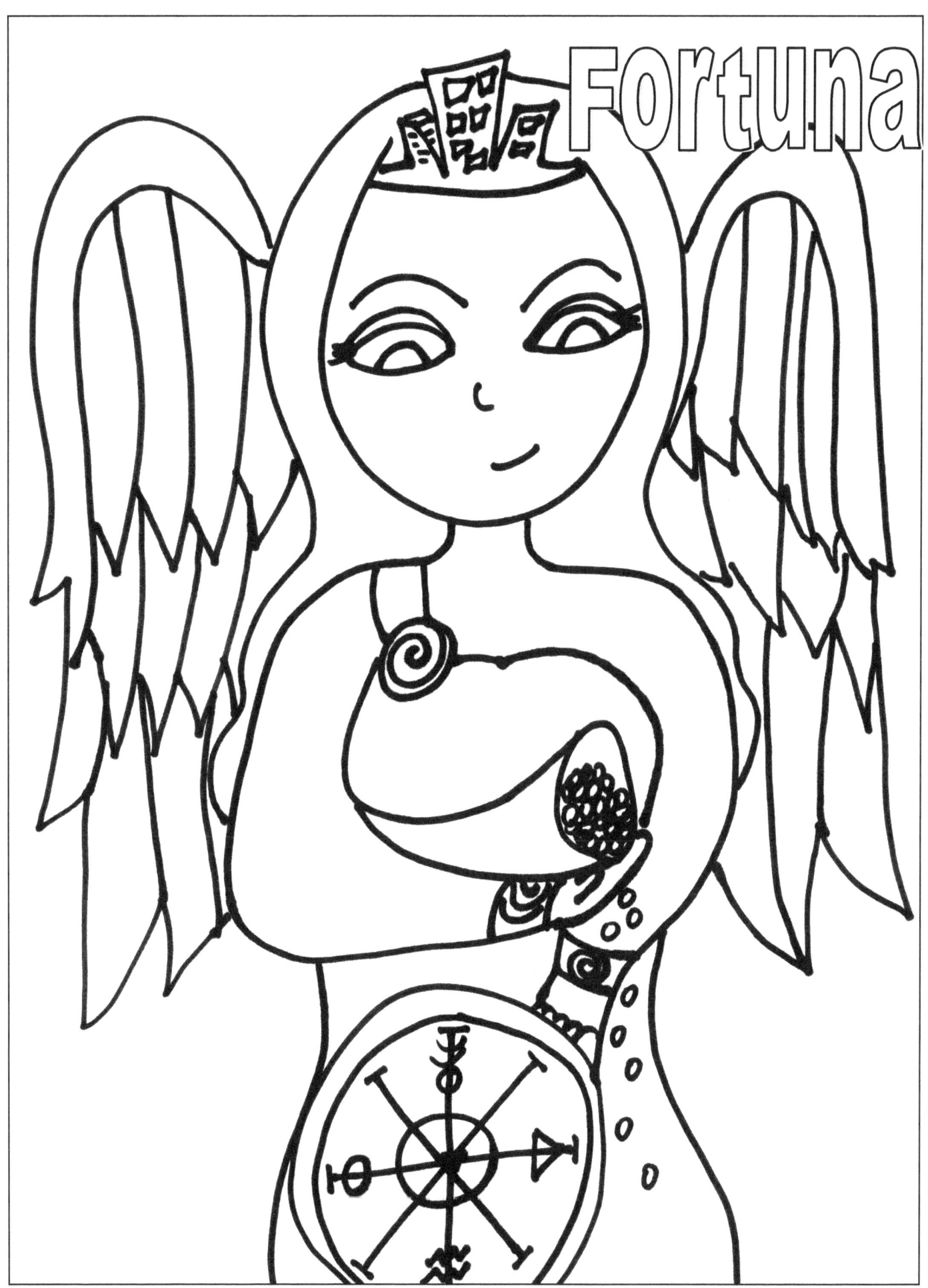

Fortuna

Goddess: Goddess of Fortune

Tradition: Roman

Meaning: Goddess of luck, fate, chance, fortune, abundance, success

Gems: Aventurine, Clear Quartz, Jade,

Colours: Green, Blue, Red, Silver

Sentence: May the wheel of fortune bless my path.

Mantra: There is plenty to go around.

Invoke: "Oh Great Fortuna, lady of luck, please bring your good luck and bright blessings my way."

Notes:

Everyday Practice five minutes of deep breathing. Sending the breath into the belly

Inhale light, Exhale Pain

Inhale peace, Exhale stress

Inhale happiness & joy
Exhale whatever is no longer serving you

Thank you!

May you live you're best possible life.

May you be happy, peaceful and loving.

May you find inner joy.

May you be continually blessed.

I am stronger everyday

Today i will find a healthy balance

5 GOaIs

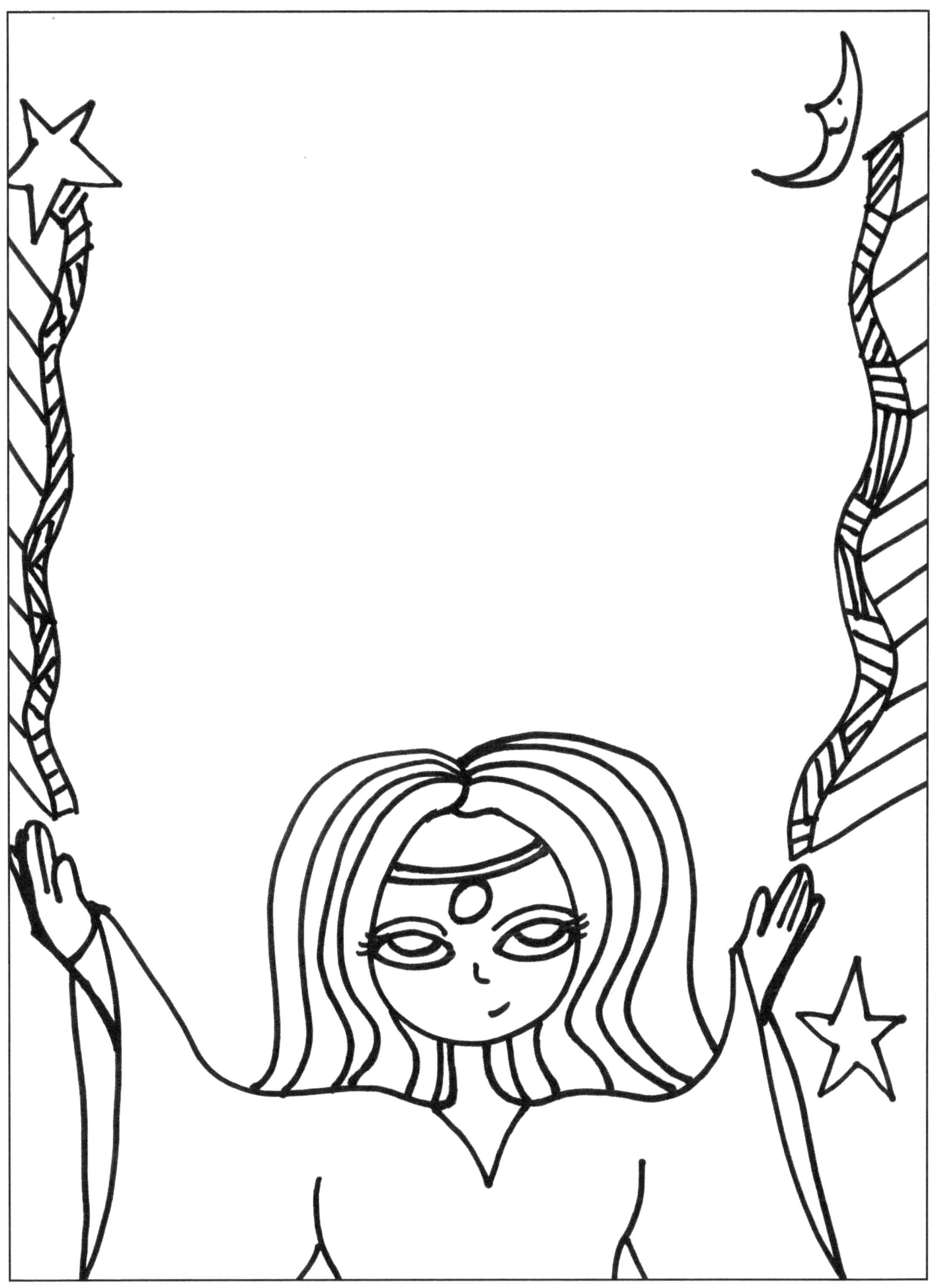

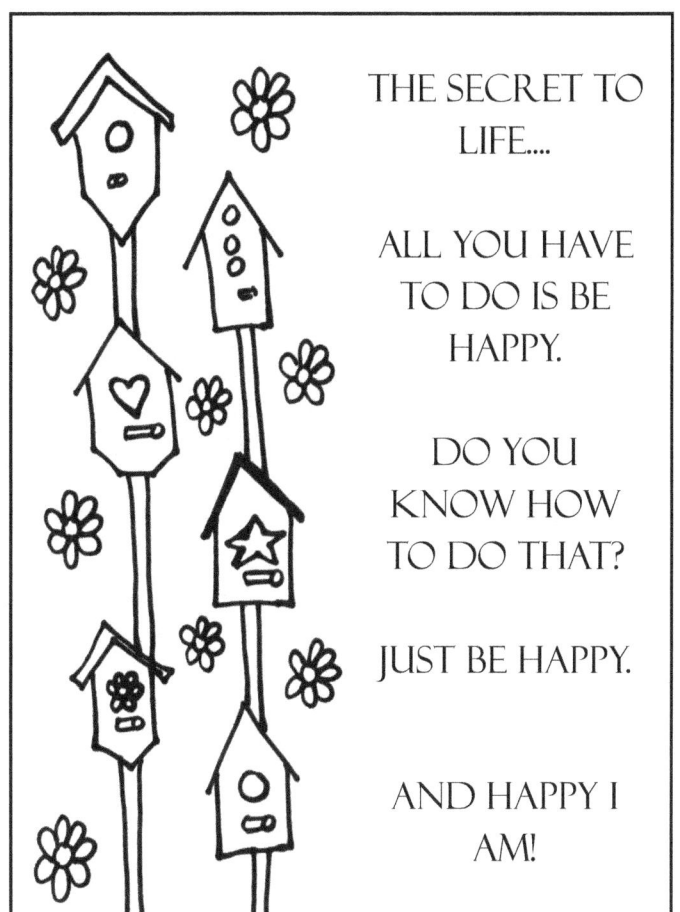

THE SECRET TO LIFE....

ALL YOU HAVE TO DO IS BE HAPPY.

DO YOU KNOW HOW TO DO THAT?

JUST BE HAPPY.

AND HAPPY I AM!

FOCUS

I am trusting this

Sending love to me...

☼ Today I will live
☼ in the moment—without fear, without
☼ regret... knowing I am divinely guided
☼ in all that I do.
I am making
☼ the right choices.
I am surrounded by
☼ love & Goddesses

I am peaceful

Focus on the Good

We don't see things
the way they are.
We see them
the way We are."
~Talmud

I see myself as a
Goddess!!!

Thank you, Thank you,
Thank you...

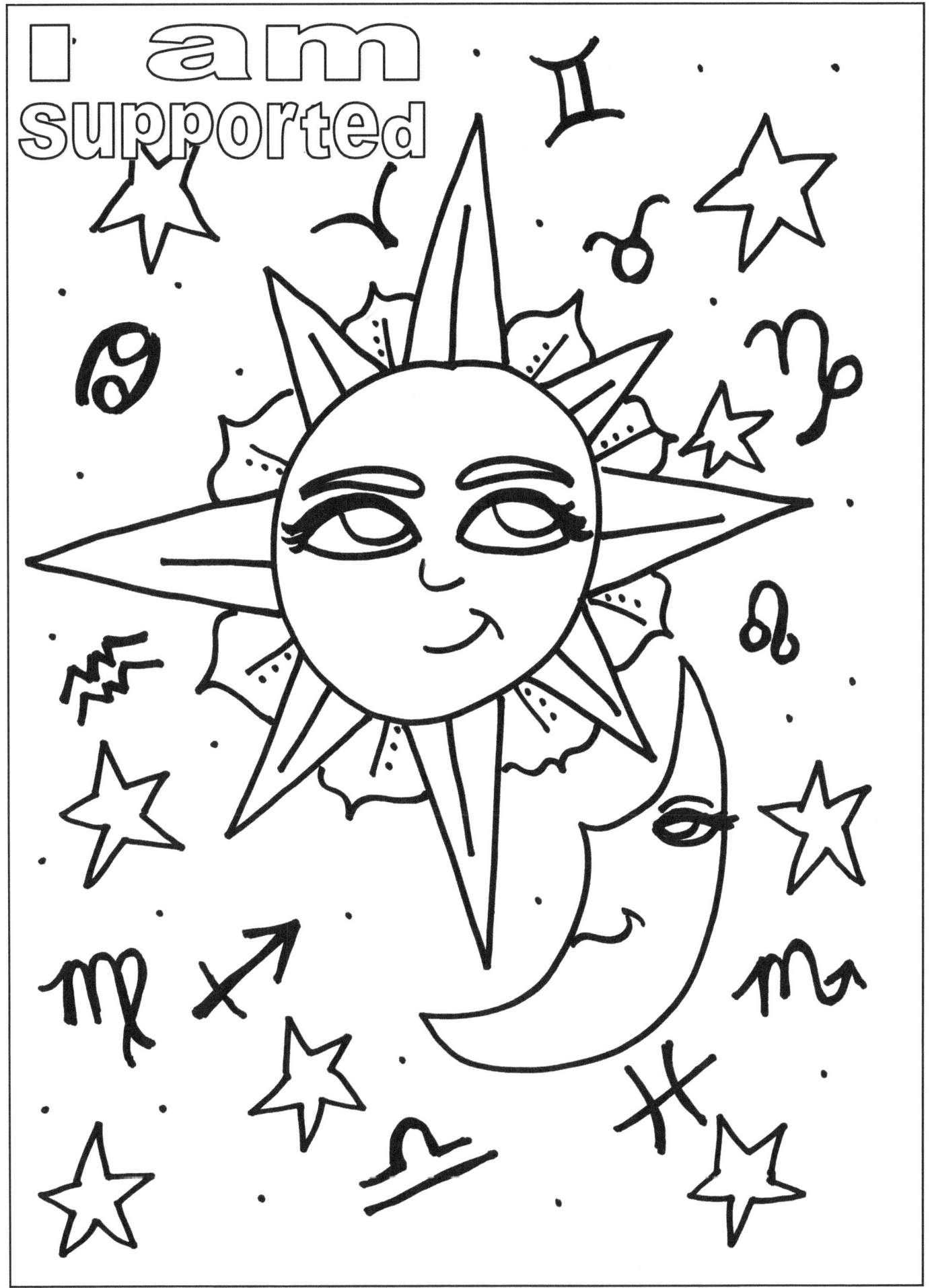

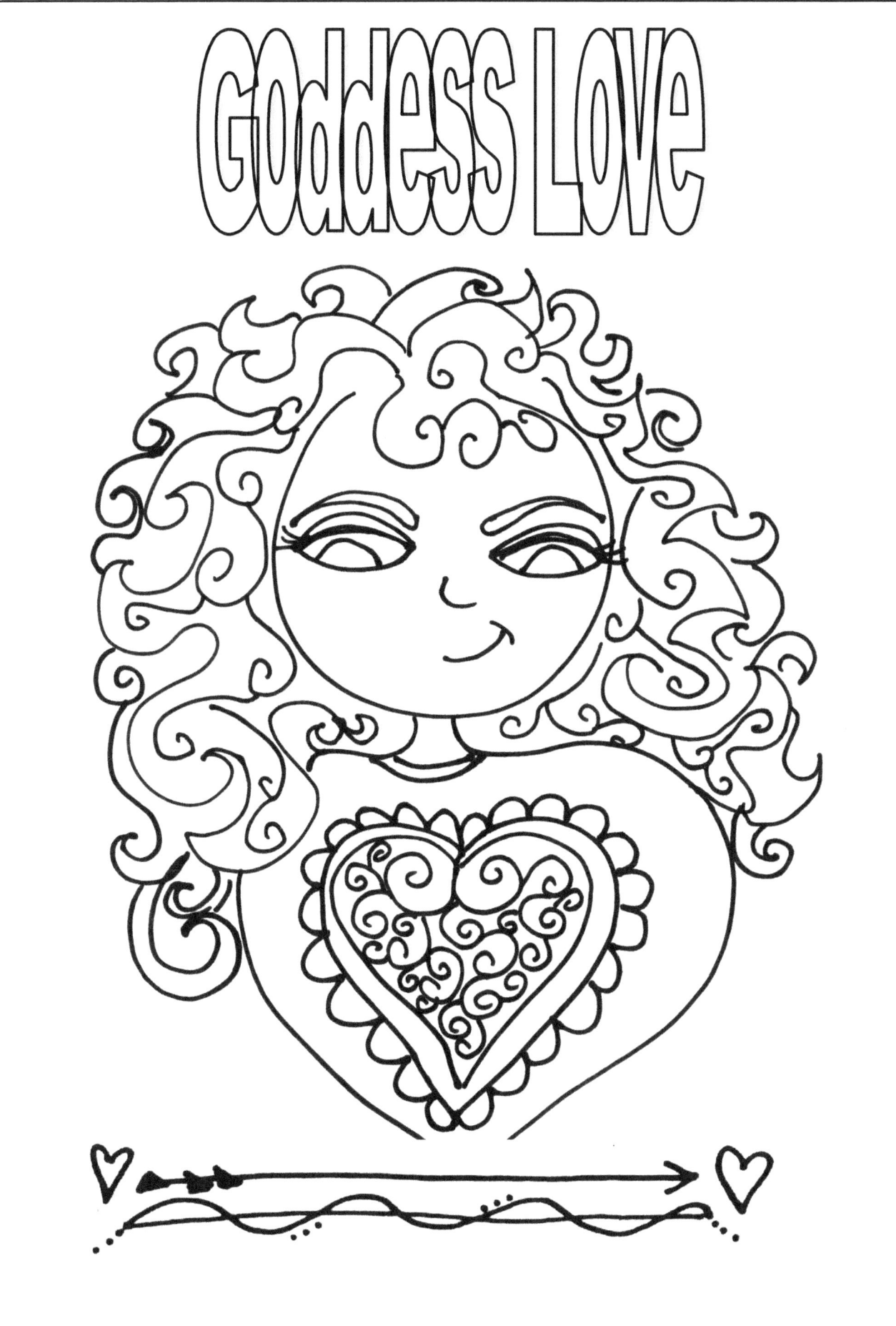

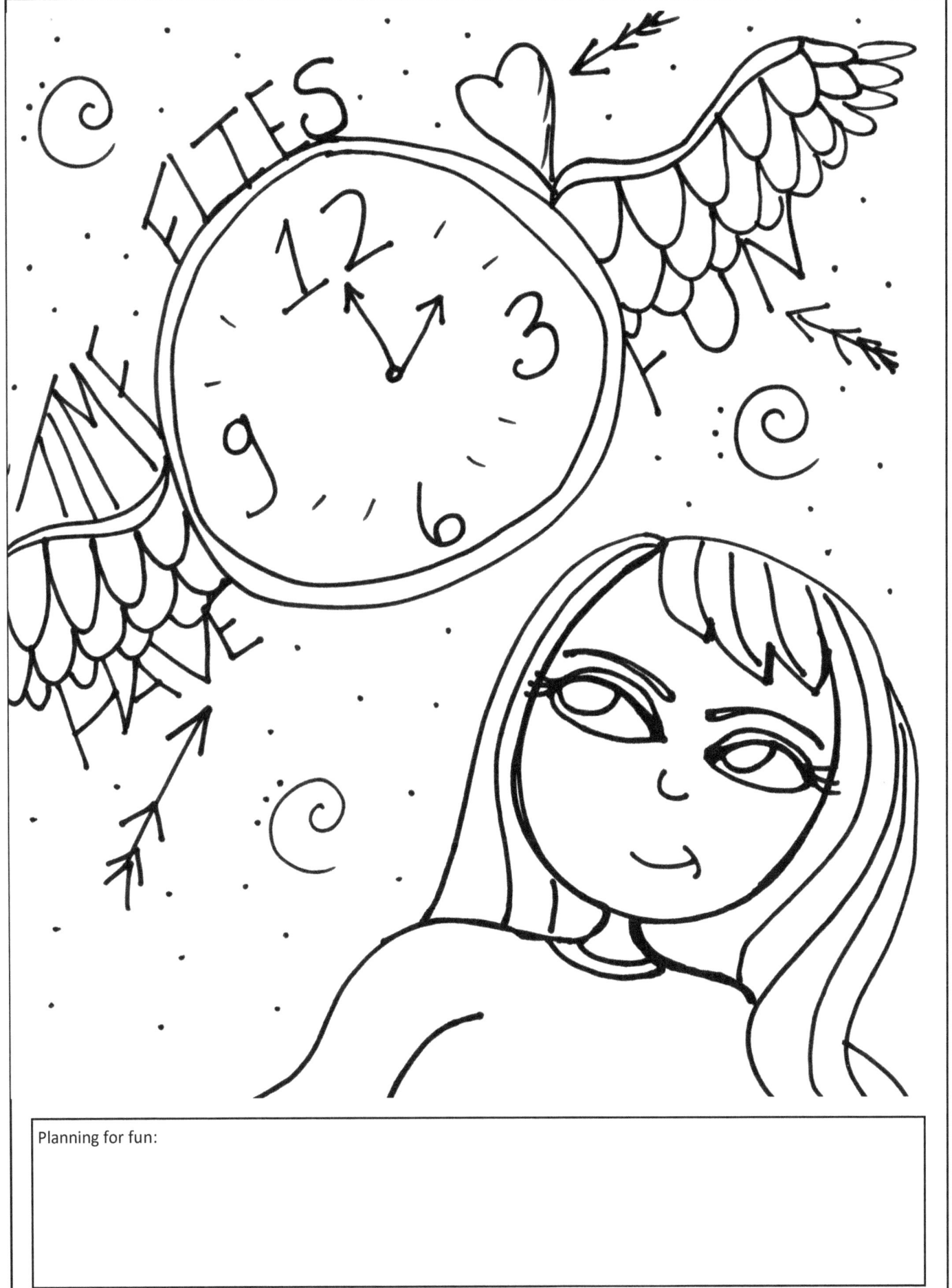

Planning for fun:

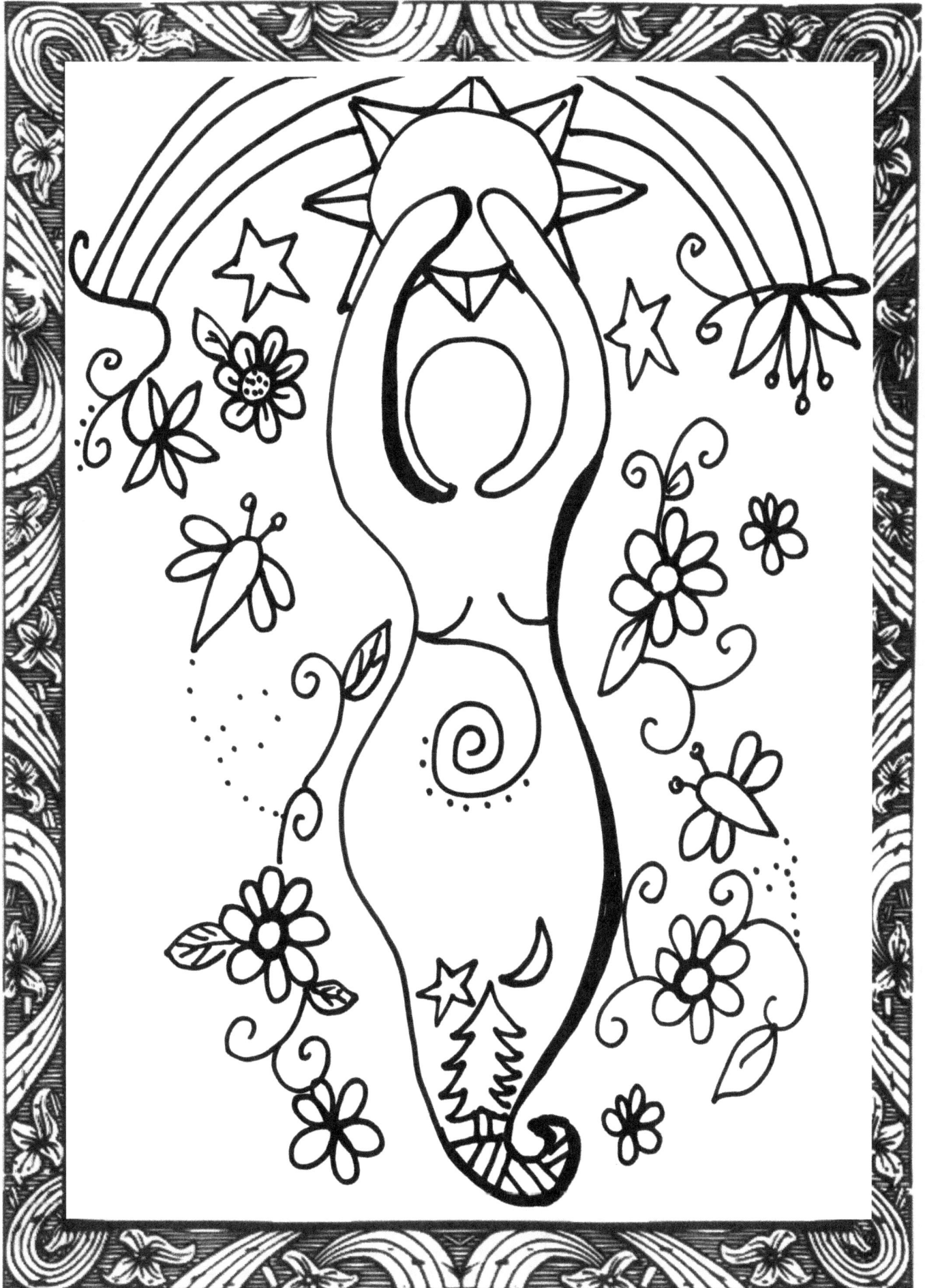

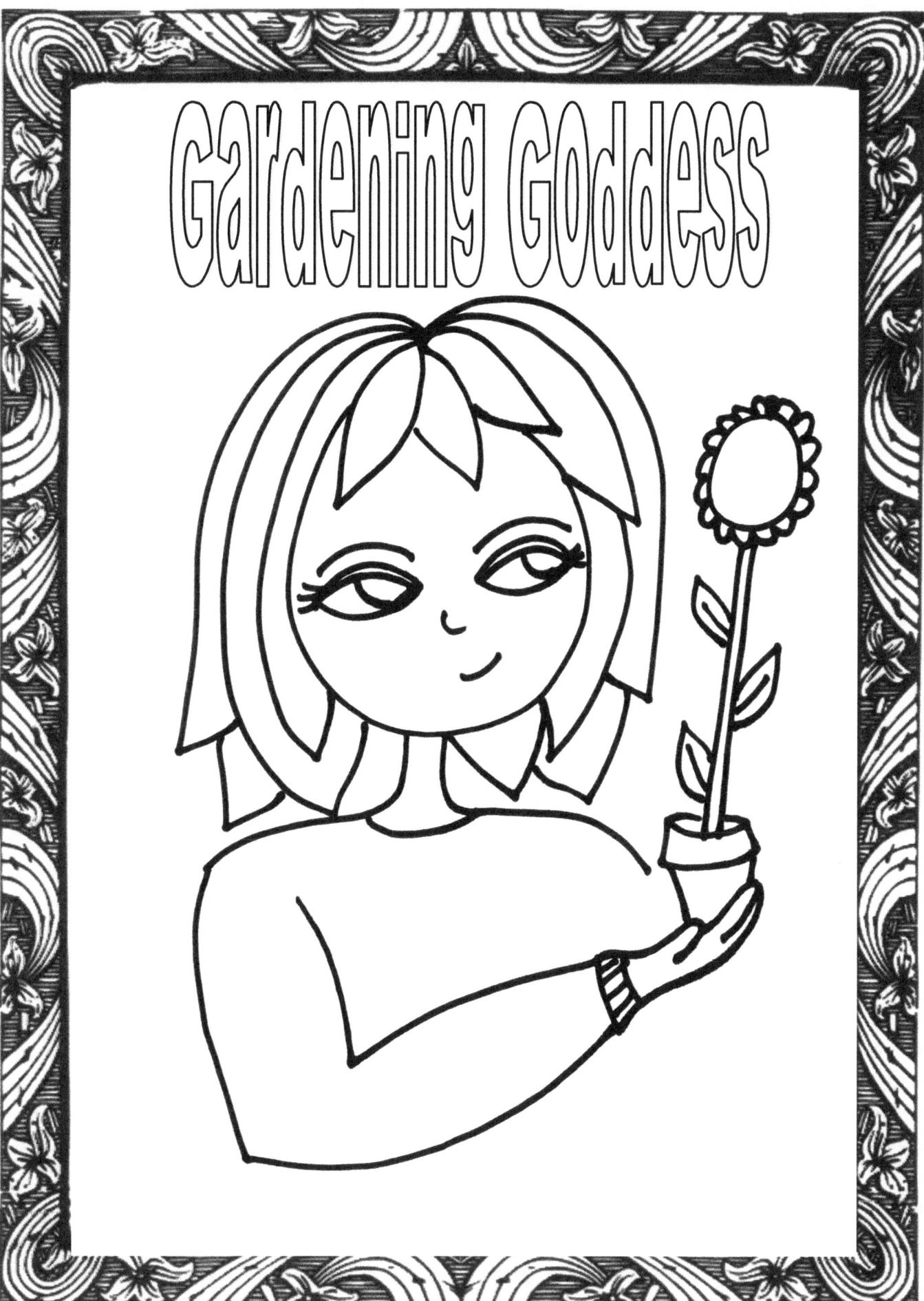

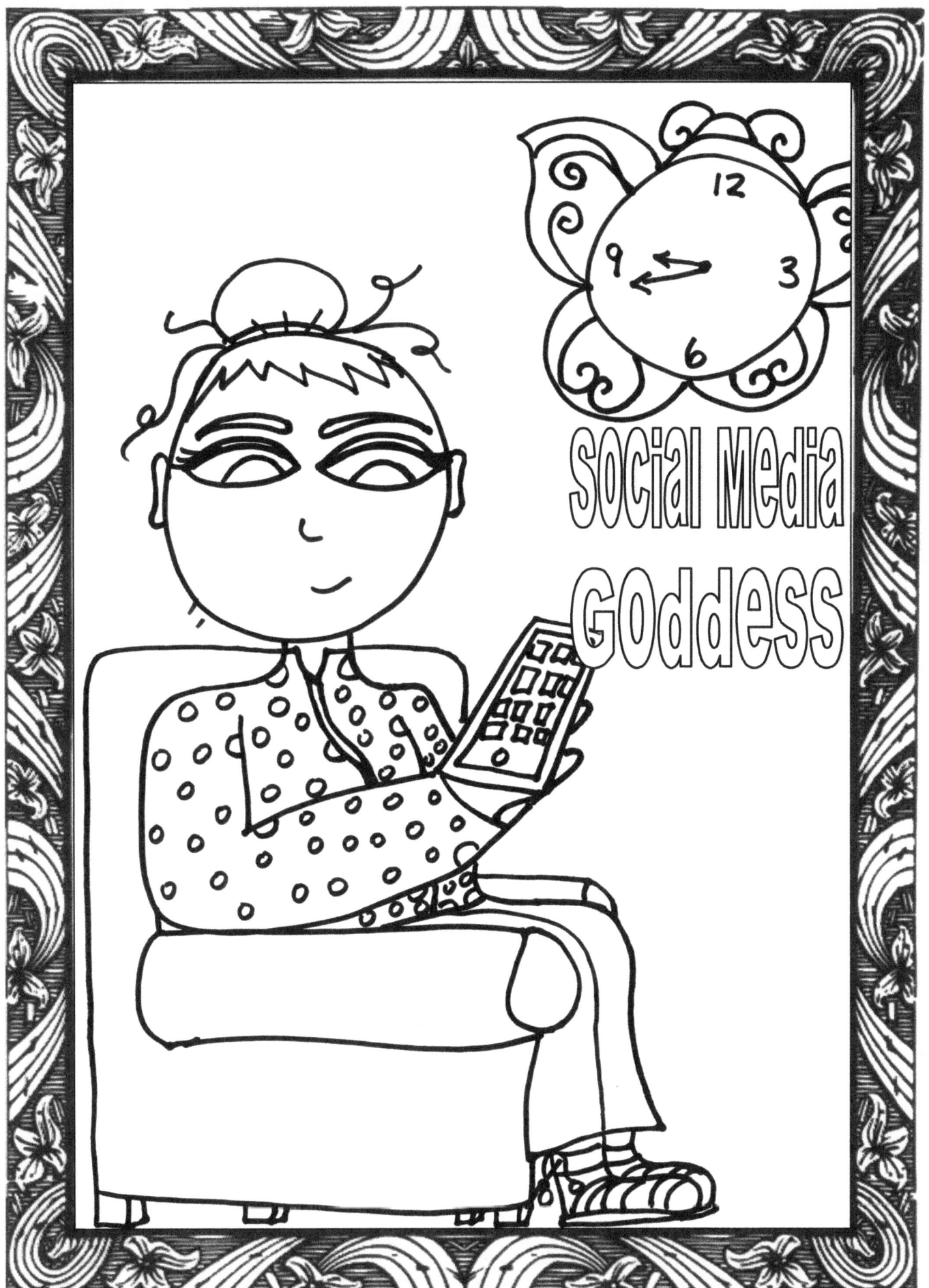

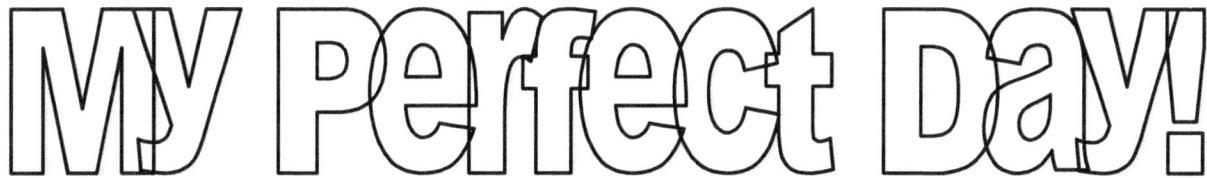

My Perfect Day!

In this space script your perfect day. What would your best day ever look like? How are you spending your time? Who are you with? What are you doing? What environment would you like to create?

Every day another blessing

About the Creator:

Tammy Lawrence-Cymbalisty is an Alternative Care provider working in the Kitchener/Waterloo Region. Since 2001 she has helped many people find peace, happiness, harmony and further purpose in their lives.

Tammy holds many degrees including: B.A. Sociology (Trent University), Certified Yoga Teacher, Reiki Master/Teacher, HypnoBirthing® Practitioner, Meditation Teacher, Workshop facilitator, Writer, Personal Growth Coach.

She lives with her husband, two felines and a school of fins in Cambridge, ON

Find out more by following Tammy on social media:

http://www.twitter.com/tllc

http://www.tinyurl.com/tlcservices

May you find peace

May you find happiness

May you be free from suffering

Namaste, Tammy

www.ingramcontent.com/pod-product-compliance
Lightning Source LLC
Chambersburg PA
CBHW081607200526

45169CB00021B/2214